# Let's Draw with Shapes™

# Let's Draw a
# Fish with Triangles

Kathy Kuhtz Campbell
Illustrations by Emily Muschinske

The Rosen Publishing Group's
PowerStart Press™
New York

Published in 2004 by The Rosen Publishing Group, Inc.
29 East 21st Street, New York, NY 10010

First Edition

Book Design: Emily Muschinske

Photo Credits: Pp. 23, 24 Kennan Ward/CORBIS.

Library of Congress Cataloging-in-Publication Data

Campbell, Kathy Kuhtz.
    Let's draw a fish with triangles / Kathy Kuhtz Campbell ; illustrations by Emily Muschinske.—1st ed.
            p. cm. — (Let's draw with shapes)
Includes index.
Summary: Offers simple instructions for using triangles to draw a fish.
    ISBN 1-40422-505-6
    1. Fishes in art—Juvenile literature. 2. Triangle in art—Juvenile literature. 3. Drawing—Technique—Juvenile literature. [1. Fishes in art. 2. Drawing—Technique.] I. Muschinske, Emily, ill. II. Title. III. Series.
    NC655 .C358 2004
    743.6'7—dc21
                                                            2003008511

Manufactured in the United States of America

2

# Contents

Draw a red triangle for the top of your fish.

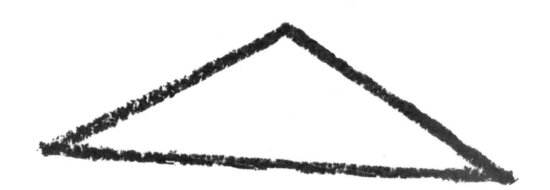

5

Add an orange triangle to
the body of your fish.

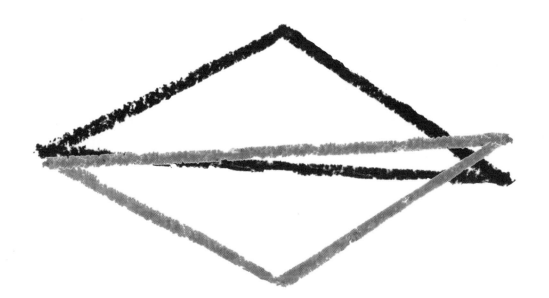

7

Add a small yellow triangle
to the top of your fish.

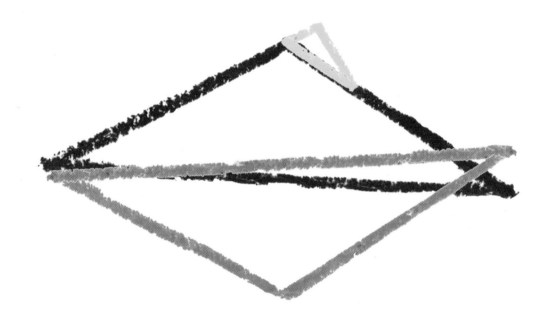

9

Add three small green triangles to the body of your fish.

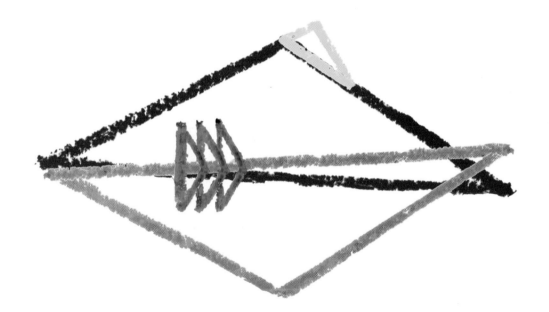

Draw a blue triangle for the top of the tail.

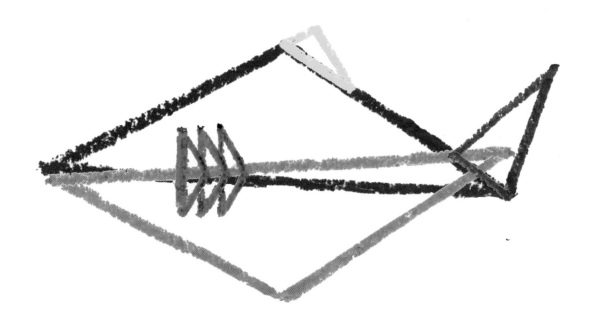

13

Add a purple triangle to the tail of your fish.

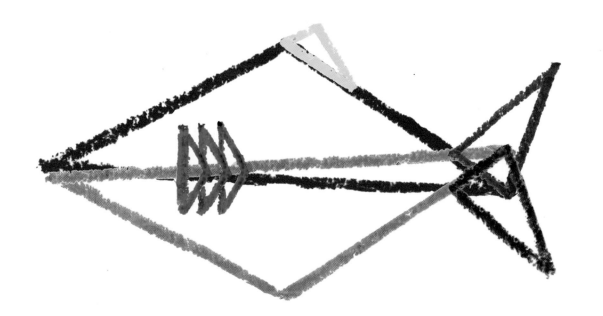

Add a small pink triangle to the body of the fish.

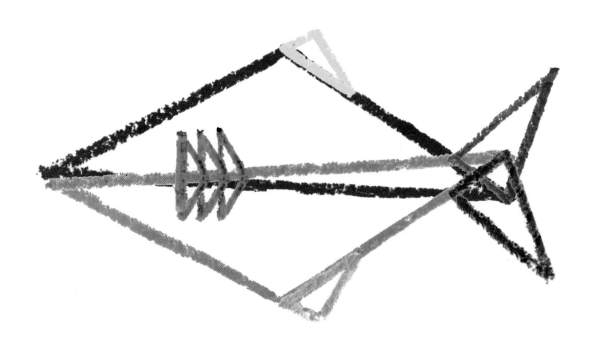

17

Draw a small black triangle
for the eye of your fish.

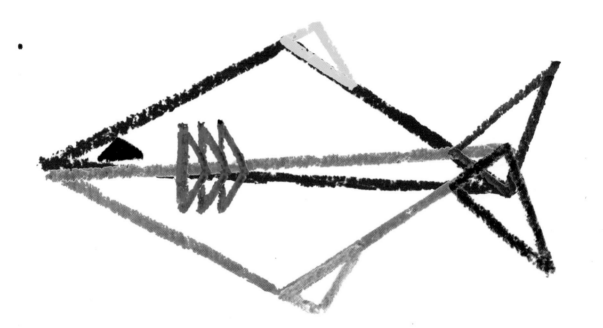

19

Color in your fish.

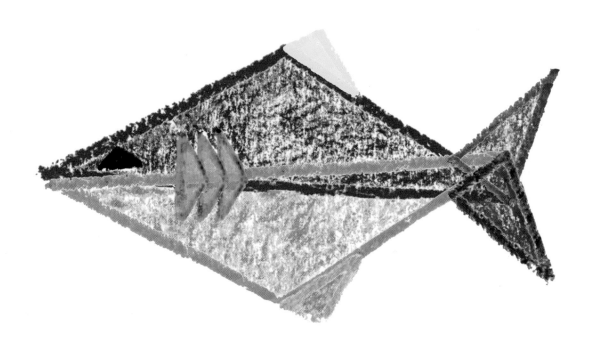

A fish uses its tail to help it swim in the water.

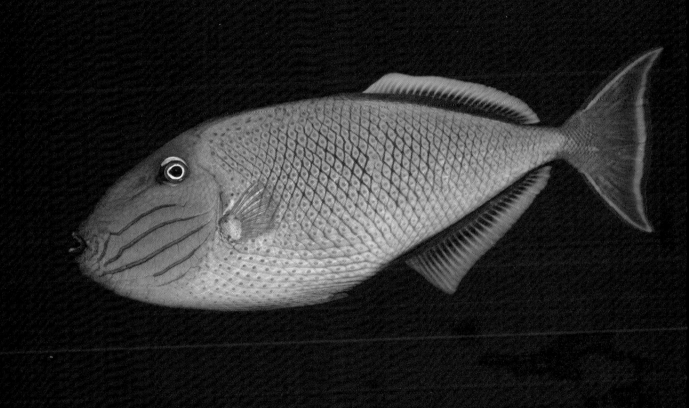

23

# Words to Know

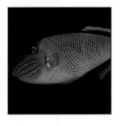
body

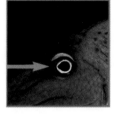
eye

tail

# Colors

# Index

# Web Sites

Due to the changing nature of Internet links, PowerStart Press has developed an online list of Web sites related to the subject of this book. This site is updated regularly. Please use this link to access the list:
www.powerkidslinks.com/ldwsh/fishtr/